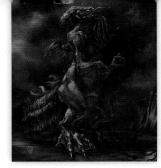

Horror Characters

The horror tradition is longstanding: The frightening myths and legends created in ancient times still influence us as we continue to create all sorts of new and vibrant ways to make each other scream and fear the dark. The fear of death and the undead is a common theme. When drawing horror characters, it's a good idea to study skeletal structures. It's also important to study objects commonly thought of as fear-inducing, such as pointed, dangerous-looking tools, insects, and decaying things, as you will likely be incorporating these into your compositions. —*Jacob Glaser*

CONTENTS

TOOLS & MATERIALS

One of the best things about drawing is that you can draw anywhere, anytime with just a piece of paper, an eraser, and a pencil. As your skills increase, you'll mostly likely want to expand your drawing tools, but it's best for beginners to just start with the basics. When you do start to purchase more supplies, remember that you get what you pay for, so purchase the best you can afford at the time and upgrade whenever possible. Although anything that will make a mark can be used for some type of drawing, you'll want to make certain your magnificent efforts will last and not fade over time. Also remember that everyone has his or her own preferences, and that experimentation is key. Here are some basic materials that will get you off to a good start.

Sketch Pads Conveniently bound drawing pads come in a wide variety of sizes, textures, weights, and bindings. They are particularly handy for making quick sketches and when drawing outdoors. You can use a large sketchbook in the studio for laying out a painting, or take a small one with you for recording quick impressions when you travel. Smooth- to medium-grain paper texture (called the "tooth") is an ideal choice.

Work Station You don't need a studio to draw, but it's a good idea to set up a work area with good lighting and enough room for you to work and lay out your tools. When drawing at night, you can use a soft white light bulb and a cool white fluorescent light so that you have both warm (yellow) and cool (blue) light. You'll also need a comfortable chair and a table (preferably near a window for natural light). You may also want to purchase a drawing board that can be adjusted to different heights and angles, as shown above.

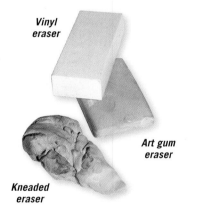

Vinyl eraser

Art gum eraser

Kneaded eraser

Artist's Erasers Different erasers serve different functions. I prefer a kneaded eraser, which can be formed into small wedges and points to remove marks in very tiny areas. I also use a hard plastic eraser, which is great for large areas. Art gum erasers are good for doing a lot of erasing, as they don't crumble easily and are less likely to damage the paper's surface.

Drawing Papers For finished works of art, using single sheets of drawing paper is best. They are available in a range of surface textures: smooth grain (plate and hot pressed), medium grain (cold pressed), and rough to very rough. The cold-pressed surface is the most versatile. It has a medium texture, but it's not totally smooth, so it makes a good surface for a variety of different drawing techniques.

Sharpeners You'll always want to keep a pencil sharpener handy, as you'll need a sharp point to make crisp, clean lines. An electric sharpener can be used but many artists prefer to use a regular hand-held sharpener, which affords more control over the shape of the pencil tip. You can also sharpen your pencil using a utility knife or by rubbing it against rough drawing paper or a sandpaper block.

Charcoal Papers Charcoal paper and tablets are also available in a variety of textures. Some of the surface finishes are quite pronounced, and you can use them to enhance the texture in your drawings. These papers also come in a variety of colors, which can add depth and visual interest to your drawings.

Light Table Light tables vary in size and ease of use, from light lap- or table-top models to the 200-pound steel monster I have in my studio. They are very useful for tracing drawings onto clean sheets of paper and for composing multi-form illustrations. For those on a budget, I recommend using a large window (simply tape your sketch to the window with the clean sheet on top of it, and trace away). This can be uncomfortable, though, and requires daylight.

PENCILS

Drawing pencils are classified by the hardness of the lead (actually graphite), which is indicated by a letter. The soft leads (labeled "B" for "black") make dense, black marks, and the hard leads (labeled "H" for "hard") produce very fine, light gray lines. An HB is somewhere between the two, making it very versatile. A number accompanies the letter to indicate how hard or soft it is—the higher the number, the harder or softer the pencil. (For example, a 4B is softer than a 2B.) In this book, I switch between a 2H and a 2B pencil, but every artist as his or her own preferences. Any of the leads can be sharpened to the point you want (as shown at right), achieving a different effect. The result will also depend on the texture of your paper. Practice shaping different points and creating different effects with each pencil by varying the pressure you put on the pencil.

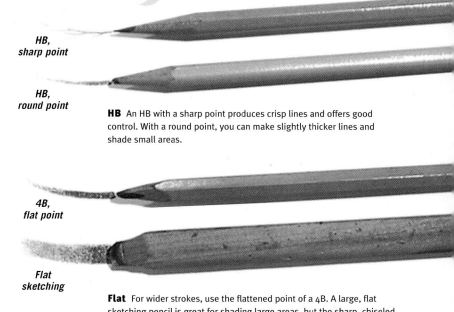

HB, sharp point

HB, round point

HB An HB with a sharp point produces crisp lines and offers good control. With a round point, you can make slightly thicker lines and shade small areas.

4B, flat point

Flat sketching

Flat For wider strokes, use the flattened point of a 4B. A large, flat sketching pencil is great for shading large areas, but the sharp, chiseled edge can be used to make thinner lines too.

Pen Input Device When choosing a pen input device, base your decision on levels of sensitivity and personal comfort. I use a medium-sized Wacom® tablet and would not want anything larger, though I know several artists who use the smallest and largest tablets available. It's a choice of personal style and comfort.

DIGITAL PAINTING

You'll notice that I don't provide step-by-step instructions for the colored finals in this book; instead, I comment on my color choices. I chose not to include exact instructions because all software programs are different and all artists will use them differently, so it won't help to explain my process with my program. But to me, talking about color choice is always helpful. There are many complicated brushes, textures, and gadgets to experiment with, but I find that the most useful brush is a basic shape, like a circle or ellipse, that has the ability to easily control opacity, size, and the brush edge (the "hardness" and "softness" of the stroke). The fundamentals of painting with physical media such as watercolor and acrylic also apply to digital painting—especially in regard to color theory (see "Color Basics" at right)—so learning them will help you become a stronger digital artist as well.

PAINTING SOFTWARE AND PEN INPUT DEVICES

Many projects in this book include a painted final, which I create using painting software. Several products exist to simulate the experience of painting for digital artists; I can't imagine a more forgiving environment in which to learn and experiment with color, value, line, and composition. You'll need access to a computer with a monitor that can display good levels of values and colors, as well as painting software and a pen input device. There are many options for painting software, including Corel Painter® and Adobe Photoshop®. Both are great programs backed by teams that continue to improve their stability, creative options, and ease of use. While painting with a mouse is possible and the results can be impressive, you won't get the most out of your painting software without a pen input device, which allows you to use an electronic pen as you would a pencil or brush.

COLOR BASICS

Color theory is an extremely broad topic, so I'll just touch on the absolute basics. The primary colors are red, yellow, and blue; all other colors are derived from these. A combination of primary colors results in a secondary color, such as purple, green, or orange; and a combination of a primary and a secondary color results in a tertiary color (like red-orange or yellow-green). Pairing complements such as red and green results in a striking contrast that can add excitement to a painting. However, when mixed, complementary colors "gray" each other, resulting in a neutral color such as gray or brown. Colors are also considered either cool or warm, which helps express mood. Warm colors—reds, oranges, and yellows— are associated with passion, energy, and anger; whereas cool colors—blues, greens, and purples—evoke a sense of peacefulness and melancholy.

THE ELEMENTS OF DRAWING

Drawing consists of three elements: line, shape, and form. The shape of an object can be described with simple one-dimensional line. The three-dimensional version of the shape is known as the object's "form." In pencil drawing, variations in value (the relative lightness or darkness of black or a color) describe form, giving an object the illusion of depth. In pencil drawing, values range from black (the darkest value) through different shades of gray to white (the lightest value). To make a two-dimensional object appear three-dimensional, you must pay attention to the values of the highlights and shadows. When shading a subject, you must always consider the light source, as this is what determines where your highlights and shadows will be.

MOVING FROM SHAPE TO FORM

The first step when creating an object is to establish a line drawing to delineate the flat area that the object takes up. This is known as the "shape" of the object. The four basic shapes—the rectangle, circle, triangle, and square—can appear to be three-dimensional by adding a few carefully placed lines that suggest additional planes. By adding ellipses to the rectangle, circle, and triangle, you've given the shapes dimension and have begun to produce a form within space. Now the shapes are a cylinder, sphere, and cone. Add a second square above and to the side of the first square, connect them with parallel lines, and you have a cube.

ADDING VALUE TO CREATE FORM

A shape can be further defined by showing how light hits the object to create highlights and shadows. First note from which direction the source of light is coming. (In these examples, the light source is beaming from the upper right.) Then add the shadows accordingly, as shown in the examples below. The *core shadow* is the darkest area on the object and is opposite the light source. The *cast shadow* is what is thrown onto a nearby surface by the object. The *highlight* is the lightest area on the object, where the reflection of light is strongest. *Reflected light,* often overlooked by beginners, is surrounding light that is reflected into the shadowed area of an object.

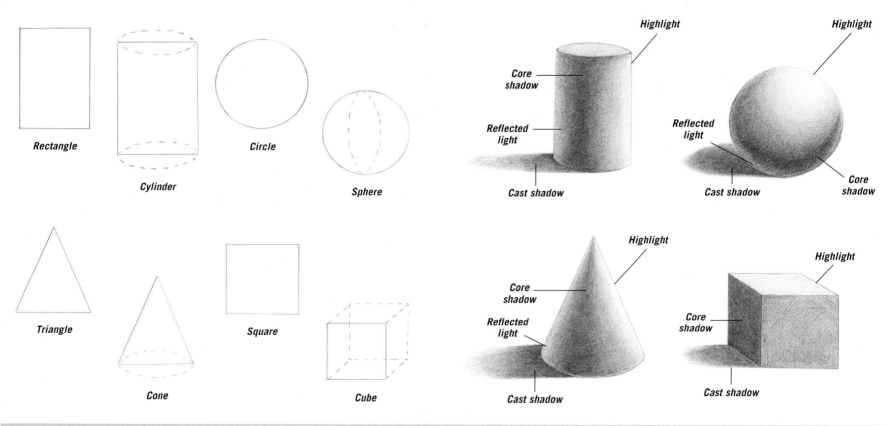

Rectangle

Cylinder

Circle

Sphere

Triangle

Cone

Square

Cube

Highlight

Core shadow

Reflected light

Cast shadow

Highlight

Reflected light

Cast shadow

Core shadow

Highlight

Core shadow

Reflected light

Cast shadow

Highlight

Core shadow

Cast shadow

CREATING VALUE SCALES

Just as a musician uses a musical scale to measure a range of notes, an artist uses a value scale to measure changes in value. You can refer to a value scale so you'll always know how dark to make your dark values and how light to make your highlights. The scale also serves as a guide for transitioning from lighter to darker shades. Making your own value scale will help familiarize you with the different variations in value. Work from light to dark, adding more and more tone for successively darker values (as shown at upper right). Then create a blended value scale (shown at lower right). Use a blending tool to smudge and blend each value into its neighboring value from light to dark to create a gradation.

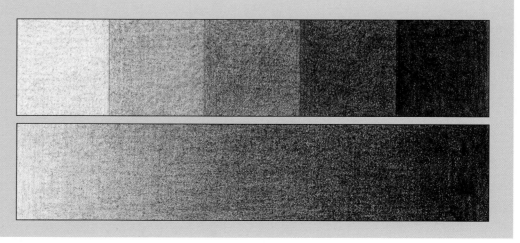

Basic Pencil Techniques

You can create an incredible variety of effects with a pencil. By using various hand positions and shading techniques, you can produce a world of different stroke shapes, lengths, widths, and weights. If you vary the way you hold the pencil, the mark the pencil makes changes. It's just as important to notice your pencil point. The shape of the tip is every bit as essential as the type of lead in the pencil. Experiment with different hand positions and techniques to see what your pencil can do!

Gripping the Pencil

Many artists use two main hand positions for drawing. The writing position is good for very detailed work that requires fine hand control. The underhand position allows for a freer stroke with more arm movement—the motion is almost like painting. (See the captions below for more information on using both hand positions.)

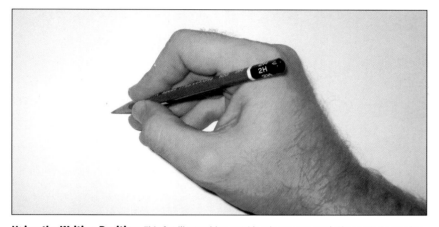

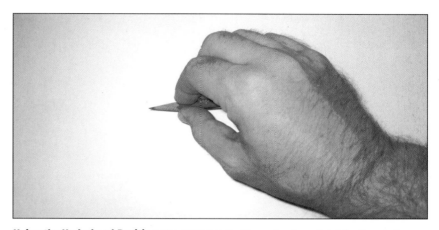

Using the Writing Position This familiar position provides the most control. The accurate, precise lines that result are perfect for rendering fine details and accents. When your hand is in this position, place a clean sheet of paper under your hand to prevent smudging.

Using the Underhand Position Pick up the pencil with your hand over it, holding the pencil between the thumb and index finger; the remaining fingers can rest alongside the pencil. You can create beautiful shading effects from this position.

Practicing Basic Techniques

By studying the basic pencil techniques below, you can learn to render everything from the rough, wrinkled skin of a monster to the soft, smooth hair of a tower-bound maiden. Whatever techniques you use, though, remember to shade evenly. Shading in a mechanical, side-to-side direction, with each stroke ending below the last, can create unwanted bands of tone throughout the shaded area. Instead, try shading evenly in a back-and-forth motion over the same area, varying the spot where the pencil point changes direction.

Hatching This basic method of shading involves filling an area with a series of parallel strokes. The closer the strokes, the darker the tone will be.

Crosshatching For darker shading, place layers of parallel strokes on top of one another at varying angles. Again, make darker values by placing the strokes closer together.

Gradating To create gradated values (from dark to light), apply heavy pressure with the side of your pencil, gradually lightening the pressure as you stroke.

Shading Darkly By applying heavy pressure to the pencil, you can create dark, linear areas of shading.

Shading with Texture For a mottled texture, use the side of the pencil tip to apply small, uneven strokes.

Blending To smooth out the transitions between strokes, gently rub the lines with a blending tool or tissue.

CREATING TEXTURES

Textures are not entities that exist on their own; they are attached to a form and are subject to the same basic rules as all other forms. A texture should be rendered by the way it is affected by the light source and should be used to build the form on which it lies. Texture shouldn't be confused with pattern, which is the tone or coloration of the material. Blindly filling an area with texture will not improve a drawing, but using the texture to build a shadow area will give the larger shape its proper weight and form in space. You should think of texture as a series of forms (or lack thereof) on a surface. Here are some examples to help you.

Cloth The texture of cloth will depend on the thickness and stiffness of the material. Thinner materials will have more wrinkles that bunch and conform to shapes more perfectly. As wrinkles move around a form and away from the picture plane, they compress and become more dense (which is an example of foreshortening; see page 7).

Long Hair Long hair, like cloth, has a direction and a flow to its texture. Its patterns depend on the weight of the strands and stress points. Long hair gathers into smaller forms—simply treat each form as it own sub-form that is part of the larger form. Remember that each form will be affected by the same global light source.

Scales Drawn as a series of interlocking stacked plates, scales will become more compressed as they follow forms that recede from the picture plane. I use a similar technique to create armor and chainmail.

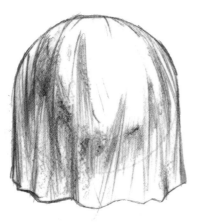

Wood If left rough and not sanded down, wood is made up of swirling lines. There is a rhythm and direction to the pattern that you need to observe and then feel out in your drawings.

Short, Fine Hair Starting at the point closest to the viewer, the hairs point toward the picture plane and can be indicated as dots. Moving out and into shadowed areas, the marks become longer and more dense.

Metal Polished metal is a mirrored surface and reflects a distorted image of whatever is around it. Metal can range from slightly dull as shown here to incredibly sharp and mirror-like. The shapes reflected will be abstract with hard edges, and the reflected light will be very bright.

Feathers and Leaves As with short hair, stiff feathers or leaves are long and a bit thick. The forms closest to the viewer are compressed, and those farther away from the viewer are longer.

Curly Hair With curly hair, it's important to follow the pattern of highlights, core shadow, and reflected light (see page 4). Unruly and wild patterns will increase the impression of dreaded or tangled hair.

Rope The series of braided cords that make up rope create a pattern that compresses as it wraps around a surface and moves away from the picture plane.

PERSPECTIVE BASICS

Another important aspect in creating convincing drawings is the understanding of the basic principles of *perspective*, or the visual cues that help create the illusion of depth and distance in a drawing. Perspective can be broken down into two major types: linear and atmospheric. In linear perspective, objects appear smaller in scale as they recede from the picture plane. In atmospheric perspective, objects that are farther away have fewer details and appear bluer and cooler in color, whereas objects closer to the viewer are more detailed and warmer in color. With linear perspective, it's important to remember that the horizon line (an imaginary horizontal line where receding lines meet) can be the actual horizon or a line that falls at eye level. When working on any drawing, having an idea of the eye level of the viewer is important so you can apply perspective to the forms. When drawing figures, ellipses are especially useful in establishing and enforcing the direction and topography of forms.

FORESHORTENING

As with linear perspective, parts of the body that are closest to the viewer seem larger than those farthest away. To represent this in your drawings, you must use *foreshortening*, which pertains only to objects that are not parallel to the picture plane. Because of your viewing angle, you must shorten the lines on the sides of the nearest object to show that it recedes in the distance. For example: If you look at someone holding his arm straight down against the side of his body, the arm is vertical (and parallel to the picture plane), so it appears to be in proportion with the rest of the body. But if he raises his arm and points it directly at you, the arm is now angled (and no longer parallel to the picture plane) and appears disproportionate. (The hand looks bigger and the arm looks shorter.) Translate this shift in size relationship to your drawing, and you'll convey an accurate sense of foreshortening.

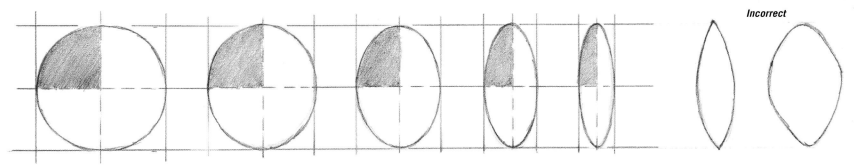

Incorrect

Drawing Ellipses An ellipse is merely a circle that has been foreshortened, as discussed above. It's important for artists to be able to correctly draw an ellipse, as it is one of the most basic shapes used in drawing. Try drawing a series of ellipses, as shown here. Start by drawing a perfect square; then bisect it with a horizontal line and a vertical line. Extend the horizontal lines created by the top and bottom of the square; also extend the center horizontal line to the far right. Create a series of rectangles that reduce in width along the horizontal line. Go back to the square and draw a curve from point to point in one of the quarters, as shown here. Repeat this same curve in the remaining quarters (turn the paper as you draw if it helps), and you will have created a perfect circle within the square. Repeat this process in each of the narrowing rectangles to produce a range of ellipses. Use this exercise whenever you have difficulty drawing a symmetrical ellipse or circle.

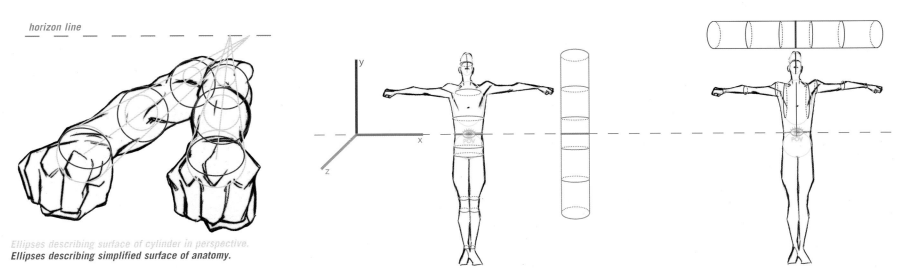

horizon line

Ellipses describing surface of cylinder in perspective.
Ellipses describing simplified surface of anatomy.

Foreshortening As discussed above, when a limb or other extremity (like a finger) moves so that the center axis becomes perpendicular to the picture plane, the forms that make up the object appear to overlap and increase in size, meaning that they are foreshortened. Understanding the basic forms and the ellipses that describe the surface will help you understand and draw foreshortened forms.

Ellipses in Perspective The figure is basically a large cylinder. When the horizon line is at waist height, ellipses around the torso that are parallel to the ground appear as straight lines. Ellipses above this line appear as if we are looking up at them, and ellipses below the line appear as if we are looking down on them. The closer the viewer is to the object, the more dramatic this effect becomes. This is also true moving left and right of the point of view (labeled POV). The closer the ellipses move toward the center, the more they open up. Again, the closer the viewer is to the object, the more dramatic the effect.

FRANKENSTEIN'S MONSTER

Written at the beginning of the Industrial Revolution—when science seemed to hold the keys to man's progress—Mary Shelley's story of Dr. Frankenstein's attempt to defy the laws of nature spawned the allegorical tale of science run amuck. Frankenstein's monster is unable to find his place in the world other than as a horrible, monstrous mistake. Giving a creature the mind of a child but the body of a huge, powerfully built man made for unfortunate outcomes.

▶ **Concept Sketches** I'm looking for a pose that shows the lurching, unsteady walk of someone learning to walk or just unfamiliar with his body.

Step One I decide on a pose reminiscent of a baby learning to walk. I feel it's a good contrast and less contrived than the standard arms-extended stiff walk of the Boris Karloff reprisal. With a 2H pencil, I lightly trace the pose using a light-box, focusing on capturing the pose with hand, feet, and head placement.

Step Two Still working lightly, I build up the basic forms and note the anatomical points: major muscle groups, points of articulation, and bones that show at the surface. I place a horizon line low in the frame since I want the figure to loom, and I place ellipses along the body to indicate a low point of view.

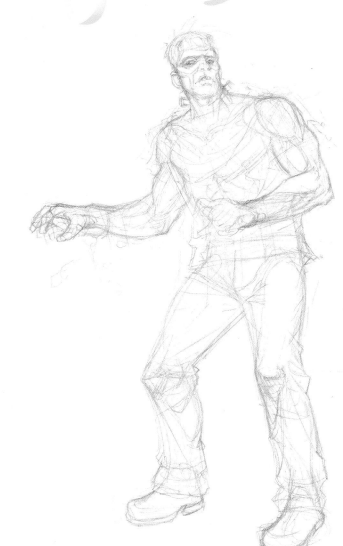

Step Three Now I get more specific with the anatomy and facial features. I also try to figure out a good pose for the hands and fingers. Since the body is composed of mismatched parts, I try to be a bit off with proportions and symmetry. I also note which forms are overlapping and create hard edges to define form, direction, and shadow edges.

Step Four I work back into the face, trying to get the personality and dull grimace across, as well as a square, too-tall skull. I lightly start to gesture in the costume, thinking of the forms of the drapery and how they wrap around the body. I want something different from the standard over-sized suit á la Boris—maybe a bit more modern.

Step Five I develop more details of the surface anatomy and clothing. I want the clothing to resemble well-worn hand-me-downs, so I indicate holes and frayed edges. I add the wrist cuff and chain to indicate an intent to hold him in captivity. I draw along the forms of the shoes and add some structure to build the idea of heavy boots. I also start to indicate some of the shadow patterns in the legs and torso.

Step Six Now that I have a strong idea of where I want to go, I begin to lay in final lines, starting with the face. I am mostly outlining, concentrating on line edges and forms and placing shadows where they make sense.

Step Seven I work my way through the torso, outlining and then building shadow. The shirt is loose fitting, but I make sure to indicate that there is a powerful chest underneath. At the waist, I dissolve the form into a pattern of wrinkles and compression folds. As I build forms, I also indicate the lines of incision and stitches for the different bits that have been pieced together.

Step Eight First I erase as much of the construction lines as I can. Then, after I outline all the forms, I go back through to add texture or extra lines to show form or stress on fabric. I develop the head a bit more to build up its bulk and make it more square. I also deepen the shadows around the eyes to give a more sunken look to his face.

▶ **Step Nine** I want to indicate many different types of skin patched together and to keep the colors saturated but dark. I choose dark colors and avoid using too much green, which seems to be the standard color for Frank these days. I add stripes to the shirt to give a stronger indication of a childish mind trapped in a brute's body.

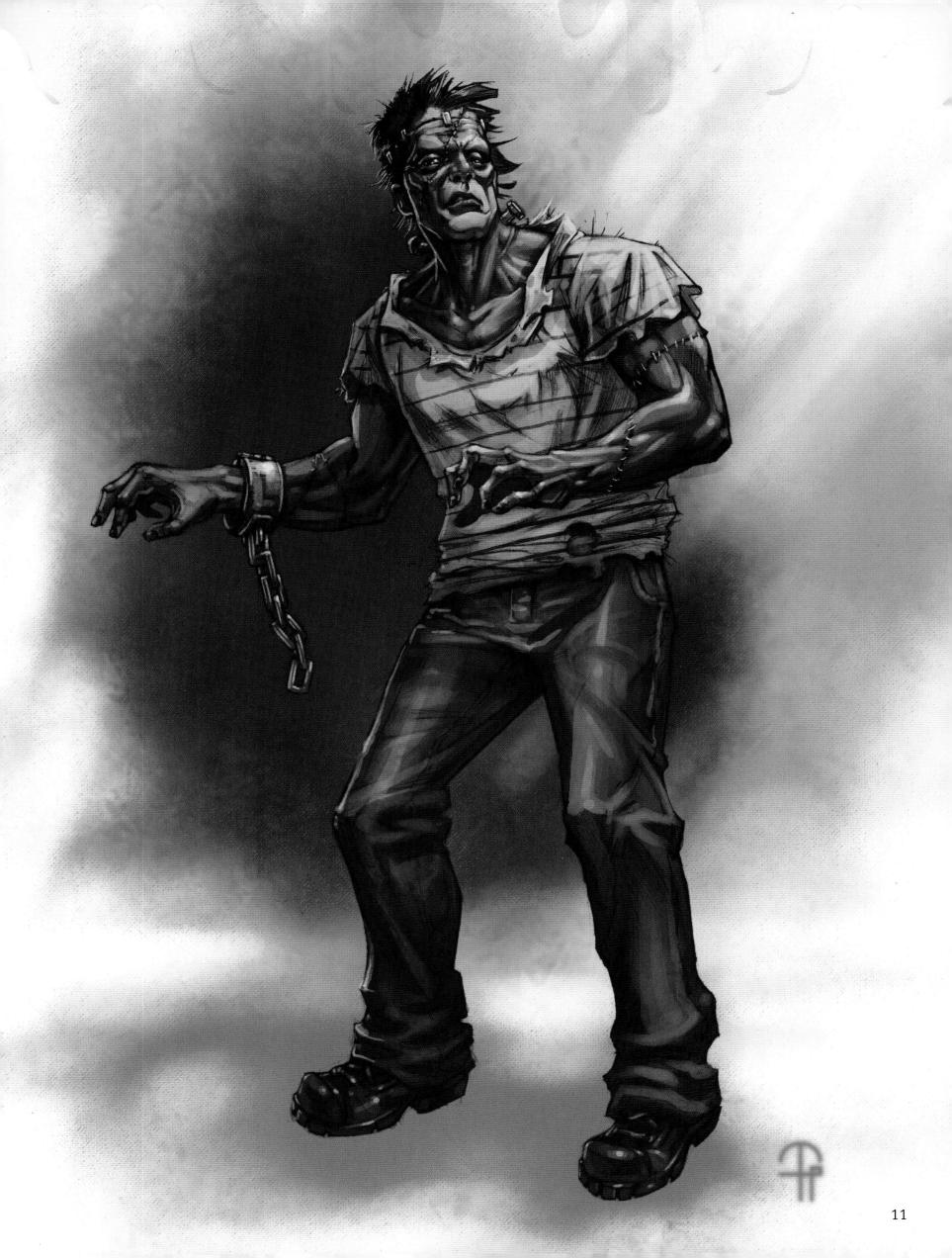

Vampire

Vampires are the risen dead who have been cursed by the bite of another vampire (or other means) and can only derive sustenance from the blood of the living. Modern Western folklore holds that most vampires are charming and elegant with an air of decrepit age and ancient evil. At their best, vampires are able to attract and repulse victims at the same time. Depictions of vampires greatly vary in popular culture, and the bloodsucking undead are used as analogies for all sorts of human behavior. As story elements, they possess a seemingly endless well of melodrama built into the conflict between their once human existence and their true vampire nature.

Step One I lightly sketch the pose with a 2H pencil, starting with the centerline (or line of action) and a few lines to define the torso, legs, and arms. I'm aiming for a general idea of the proportions and position of the figure. I'm not worried about being too exact because I will most likely move everything around a bit as I develop the character.

Step Two I change the angle of the head a bit and start defining major areas of the figure, including the coat. I want the character to have a sinuous body with signs of age and atrophy, so I exaggerate joints and bone structure, especially in the hands, feet, and face. I study the proportions of elderly men for reference.

Step Three Vampires are depicted in all kinds of costumes and clothing; I prefer those from the Edwardian/Victorian era, so I develop a coat with some details reminiscent of armor. I want the clothing to have a kind of dapper and aged look. I also start to experiment with the vampire's hair and facial expression.

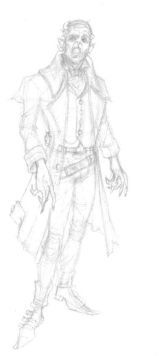

Step Four Still using a 2H, I continue developing the costume and figure. I want to fully capture the facial expression and textures before I start placing final lines, as they'll be harder to erase. I want his hands to look aged and powerful; more lizard or rat than human. I make the knuckles large, the veins prominent, and the fingers sharp. Then I begin adding details to the coat, pants, and shoes.

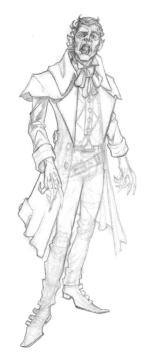

Step Five Now I switch to a 2B to start darkening lines and adding shadows, erasing construction lines as I go. I also add curving lines to the hair to show motion. Then I add a checker pattern to the vest and change the shape and size of the bow at the neck.

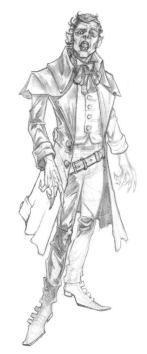

Step Six I didn't like the checker pattern so I removed it with a kneaded eraser. I continue working up shadows and filling in dark areas of the clothing, leaving white areas for highlights. I also add frayed edges to the coat to show age.

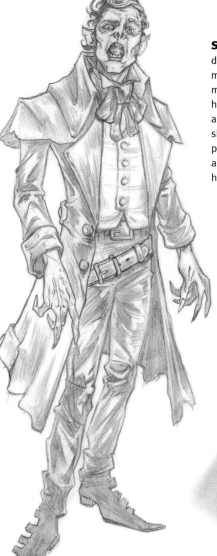

Step Seven I finish adding details and refining the figure, making the vampire's fangs more prominent. I make the hands looks especially veiny and ancient, complete with long, sharp nails. To finish, I use a plastic eraser to clean up edges and create more areas of highlights.

Step Eight I scan my final drawing. Then, using Photoshop® to color it, I begin with a grayscale painting and add various neutral shades of brown and black to the clothing. To give the skin a dead, cold feeling, I use a pale teal with accents of rust to show blood stains and a tiny bit of life. The bright red of the eyes and the mouth draw the viewer into the vampire's horrifying expression and dangerously sharp fangs.

DID YOU KNOW?

Vampire myths exist all over the world and vary quite a bit in regards to the monsters' attributes and weaknesses. For instance, Chinese vampires suck *chi* (life energy) instead of blood, and older Western myths say that vampires cannot cross running water and lack a reflection and/or shadow.

13

WITCH

Witches have a better reputation these days than they did in Cotton Mather's time, but the idea of supernatural power used for evil by a loveless old crone still has the power to instill fear. Twisted by the evil forces to which they have aligned themselves, witches use their powers to stay beautiful or just go with it and look the part of a scary old hag. In the past, a fear of old women with an affinity for herbal medicine transformed into a hysteria that left us with a ghastly mythology of witches eating babies, souring milk, turning people into animals, and consorting with devils.

Concept Sketches I try out a few of the common pointy hat and broom witch designs but decide to go a different route. I like the idea of incorporating some sort of ritualistic knife and having the wind blow her hair around.

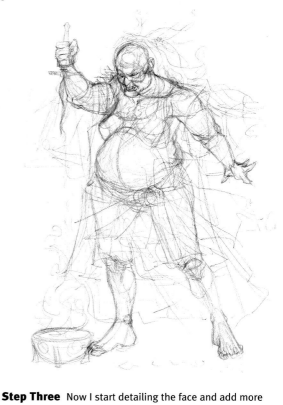

Step One None of the concept sketches are exactly what I want but I use a few of the ideas to sketch a pose with a 2H pencil. I like the arm and leg being thrown back and a bulky body type so I indicate all of that. I gesture in a bit of costume and the knife as well.

Step Two Now I start placing more specific forms, spending a bit more time on the face to get an idea of how it will affect the body position. When placing the forms, surface anatomy is less important than body proportions and the direction of major forms. I don't like the way the head was positioned and I want to exaggerate the thrust of the right arm, so I remove portions with a kneaded eraser. Then I place a new oval for the head with a centerline that indicates she is looking down. I work out some surface details and have fun drawing all the folds of fat. Most of this will be covered by the costume but it helps me understand the forms better and get into the character a bit more.

Step Three Now I start detailing the face and add more of the costume and hair. I add a little brassier, which I want to be her center of focus and a light source in the painting stage. I follow the ellipses around the forms of the body and try to reinforce the pose and form of each shape with the cloth that covers it.

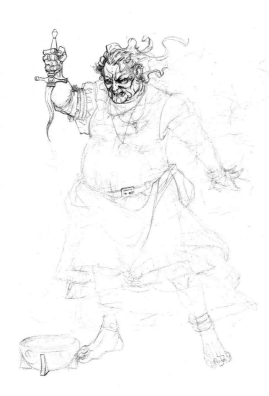

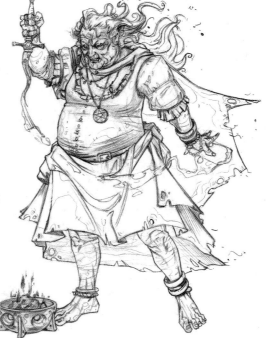

Step Four Still working lightly, I resolve the surface texture, especially on her face and hair. I try out a few ideas with the costume and add a few bracelets and a spray of blood coming from her cut hand. I have overworked this drawing a bit and some of the details are distracting, so I erase a great deal with the kneaded eraser. With the 2B pencil I rework the face and some of the hair and move into the raised arm. Then I go back into the skirt and blouse with the 2H to get the flow of fabric and details that I want.

Step Five I use the 2B to finalize the lines and details as I add them. Then I start to place lines to indicate shadow edges and texture. I am mostly outlining, defining forms, and adding shadow and texture as I move through the drawing. I finish the outlines and go back through to further define shadow and texture. I erase as many construction lines as I can and any areas of overworked texture.

Step Six The nighttime palette shifts to saturated violets in the shadows with the white light of the moon, and the primary light source is the sickly lime green of the brassier. Lighting everything with bright green helps bring out the red of the blood.

EVIL SCIENTIST

Dr. Jekyll, Dr. Frankenstein, Dr. Moreau: Where would we be without our mad scientists? Mix a man (or woman) with a vision and a slight God complex, add a lack of foresight into the potentially horrific consequences, or a tragic science lab accident, and you get horror gold. In an age when witchcraft seems less credulous, these are the new purveyors of the bizarre and terrible curses on humanity: Science gone awry. The challenge here is to show both madness and discovery.

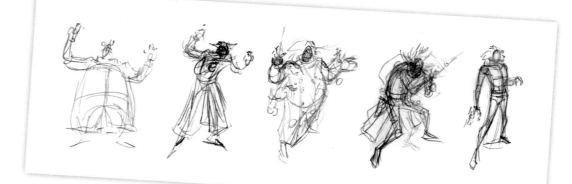

Concept Sketches I plan on covering madness in the look of the character, but as for discovery and science, I want a pose that captures the "Ah-ha!" or, rather, the "It's alive!" moment.

Step One None of the thumbnail sketches is exactly what I want, but I go ahead with one of the poses, sketching it with a 2H pencil. Here the character crouches with a test tube held up in a moment of evil celebration.

Step Two I lightly block in the basic forms, trying to get an idea of the placement of the hands, feet, and head. I draw centerlines down forms to show direction and volume. I also block in some of the costume, since he will mostly be covered by his lab coat.

Step Three Still using the 2H, I build up the clothing and details of the face and hair. Most of the figure is costume so I am conscious of the forms underneath. Next I experiment with the hair and some details on the coat.

Step Four Now I put a bit more pressure on the 2H pencil to go a step darker, and I outline edges, fill in more details, and add texture. Notice how the stress points of the coat are at the shoulders where the arms are raised; there are also stress points at the waist where the coat is buttoned across the hips. Next I lightly sketch some equipment at the back of his belt.

Step Five I'm feeling secure with the forms so I erase some construction lines and start in on the final lines, beginning with the face. The scientist is older and gaunt, so the structure of the skull is prominent. Next I add shadows, using the beaker as the light source. The arm on the right is too long so I erase it and redraw it a bit higher, making the proportions more convincing.

Step Six Now I switch to a 2B and continue moving down from the head, finding shadows and form edges. I also add stress lines and folds to the coat. At this point I am mostly concerned with edges and forms.

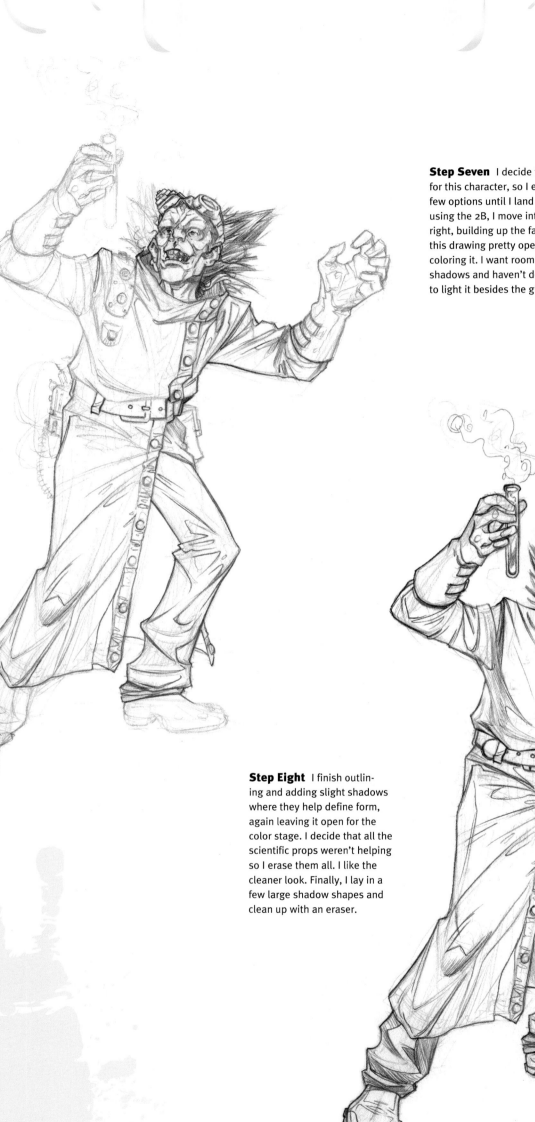

Step Seven I decide the hair isn't right for this character, so I erase it and try a few options until I land on this one. Still using the 2B, I move into the arm on the right, building up the fabric folds. I keep this drawing pretty open since I will be coloring it. I want room to add colored shadows and haven't decided how I want to light it besides the glowing beaker.

Step Eight I finish outlining and adding slight shadows where they help define form, again leaving it open for the color stage. I decide that all the scientific props weren't helping so I erase them all. I like the cleaner look. Finally, I lay in a few large shadow shapes and clean up with an eraser.

Step Nine The palette is basically chartreuse and turquoise. I like the sickly look of the chartreuse in the vapor, and the bright blue has the cool, intellectual feel of a science lab with weird glowing stuff. I add some background elements, making it look like a dark lab or warehouse.

SUCCUBUS

Succubi are demons that take the form of women to seduce their prey and then feed off their life energy, which results in weakness, permanent injury, rapid aging, and even death of the victim. The resulting emission of energy is then used by the male counterpart to seduce and impregnate a human woman. I want to create a demonic character that is both seductive and repulsive, a figure that expresses a sinister playfulness.

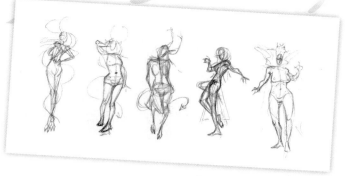

Concept Sketches There are many pin-up poses that can work here, but I want a playful come-hither look, rather than something overtly sexual.

Step One I enlarge the thumbnail I like best and trace it onto Bristol paper using a 2H. I want the pose to be appealing and a bit vulnerable. As I draw, I make sure that she doesn't look as if she'll topple over by making her head turn counter to the direction of her body.

Step Two I start to lightly place the basic shapes (cylinders, boxes, and spheres) to show how the large shapes of the body sit in space. I draw the centerline quickly so I can establish the relation of the torso to the pelvis and find the waist so I can draw the oval form of the ribcage.

Step Three Now I make my lines a bit darker and note the major anatomical points, as well as details of the anatomy that are affected by the body position. I'll be giving her the legs of a deer, so I use a reference to get the forms right.

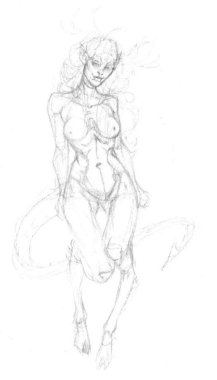

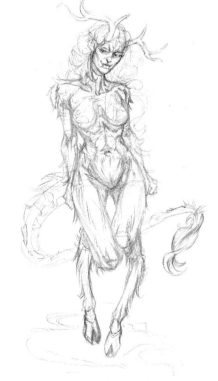

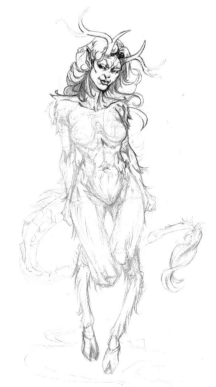

Step Four Since the anatomy is going to be mostly exposed, I take extra time to get the details and forms down. I take a stab at the facial expression and experiment with the hair and horns.

Step Five I continue adding surface details and fur patterns. I want her to have cloven hooves and horns like a demon, but I also want her to be attractive, so I soften the fur and make the horns more elegant.

Step Six Now I use a 2B pencil to develop the face and head. I change the facial expression a bit since I didn't feel confident enough with it. As I draw, I erase out shadows and areas to accentuate form.

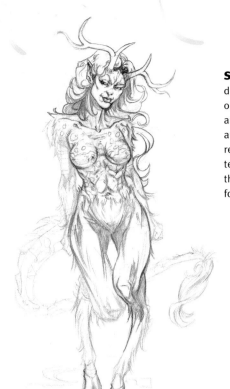

Step Seven As I move down the body, I develop the edges of shapes and build up shadows and textures. As forms recede, I compress their textures, making sure they wrap around the forms.

Step Eight Still using the 2B, I finish the outlines and large shadow areas. Then I go back through the drawing, adding extra fur textures and erasing any areas I may have taken too far.

Step Nine I decided on a palette of reds, gold, and pinks. I want the figure to have more "real" colors but the background to be more saturated and romantic.

Hell Hound

These fierce, undead protectors of hidden relics, treasure, and often their undead masters are ever-watchful sentinels. Usually the daytime protectors of vampires, these demon dogs appear to the casual observer to be nothing more than very large and bestial canines. However, when provoked, they may reveal a more demonic appearance and call on hell fire while discharging their duties. Supernaturally fast, strong, and aware, these demonic companions are no living man's best friend.

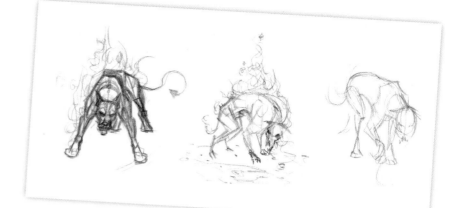

Concept Sketches Animals are a bit more challenging for me because I don't draw them as often as other subjects. I always use reference materials but tend to spend more time looking at pictures of animals to get the rhythms and postures in my head before starting the concept sketches. I want to convey the largeness and ferocity of this dog in a pose that is more extreme than your average mutt.

Step One I lightly sketch the pose with a 2H pencil, starting with the line of action and a few lines to define the silhouettes of the torso, legs, and flames. I aim for a general idea of the proportions and position of the dog, and am not worried about being too exact because I will most likely move everything around as I develop the drawing.

◄ **Step Two** As I continue to develop the hound with the 2H, I start noting major anatomical points (ribcage, pelvis, head, feet, ears, and tail) and the start of the flame pattern. The horizon line is off the page so I don't sketch it in, but I keep the idea of it in my head as I move forward.

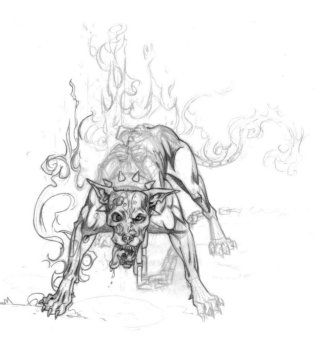

Step Three I continue developing the anatomy, using what I know about dogs and the goals I have for the character. I want a powerful yet gruesome figure, so I exaggerate bones and muscle structure, leaving some bones exposed and leaving holes in the skin and some muscles. I also start to work on the face and enraged expression, complete with drool. Then I continue developing the flame pattern. A dog's ears say a lot about its character and mood, so I make this dog's ears tattered and batlike. I continue working on the flame, playing with the rhythm of the curls. I also add some markings on the ground. Hellhounds are essentially servants so I add a powerful-looking collar and chain. Then I further develop the dog's anatomy, including the long tongue and intimidating claws.

Step Four I decide that the ambient light source is coming from above and that the flames will cast light from the left. Switching to a darker 2B pencil, I start creating the final lines, outlining shapes and adding shadows. I move all over the figure, erasing construction lines as I go. Rather than working systematically, I follow the lead of whatever occurs to me while drawing. The brow on the right side of the dog's face was looking too human so I erase and change it. Then I work on the back area of the dog, making sure the lines along the ribcage are shortened for perspective. I go in with my plastic eraser to clean up the edges and create planes of light. Then I add a few more shadows and add the final details. Note that the flames look somewhat unfinished because I'll be coloring them.

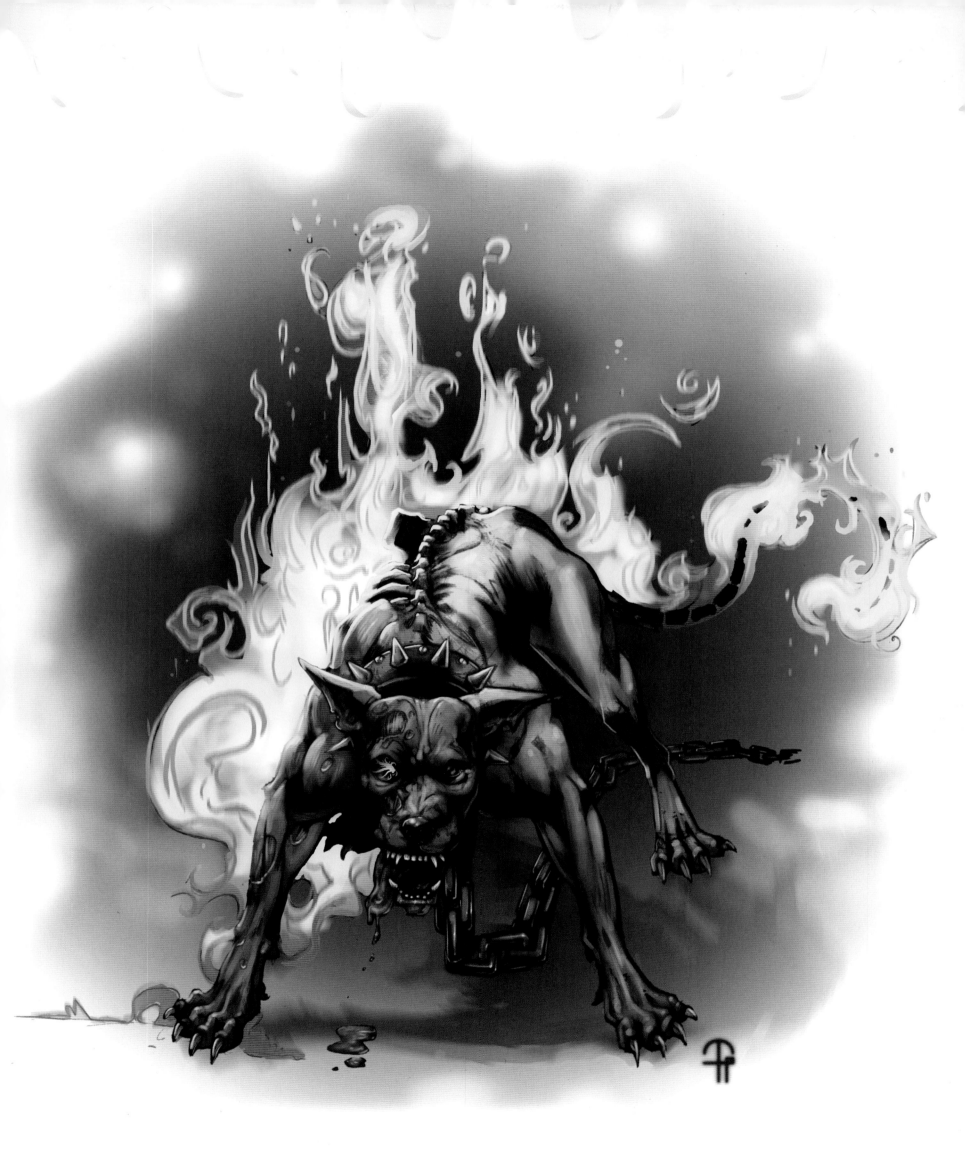

Step Five I want the side lit by the flames to look raw, so I use fleshy red tones. I use cooler tones on the right side of the dog's body to contrast the bright, saturated fire colors. I like the graphic shape of the flames so I leave in the lines and hard edges.

MAN-EATING PLANT

"The Little Shop of Horrors," the stories of Edward Gory, and tales from deep jungle explorations give accounts of man-eating plants: giant, carnivorous plants that prey on indigenous animals and will consume a man whole if one is within reach. The origins of the myth may come from the many species of flowering plants that exude the powerful smell of rotting flesh, or the many actual carnivorous plants that actively feed on insects and small animals.

▶ **Concept Sketches** With these thumbnails, I'm trying to get a general idea of the shapes I can use in the final and of the mechanics of the plant. None of them are exactly what I want but they help get ideas flowing before I start sketching.

Step One Using the side of a 2H pencil, I sketch the placement of major forms and the general shape of the plants. I don't want to just draw one plant since these large carnivorous plants generally live in lush forests. I want to indicate the complete surrounding ecosystem.

Step Two Unlike drawing humans or animals, there are no set structures to build upon, so I just start sketching random forms and shapes to see what works. Starting with the main flower, I lightly build up shapes and ideas for what this monster plant will look like. I keep in mind special forms like cylinders and domes for the central area; for other parts I think about texture and silhouette shape.

Step Three When I feel a form is working, I push down the pencil a bit harder, and I erase the lines that aren't working. I use a kneaded eraser, leaving a bit of the lines in case I want to come back to them. I am trying to build up dense vegetation, so most of the lines can remain as texture until I decide that they are not needed.

Step Four At this point I begin to see what the specific forms are, so I use the side of the 2H to place some larger shadow areas to clarify form. Then I go in with the pencil point to develop smaller details like the small flowers and the skull.

Step Five The structure is developed enough to start making final decisions, so I use the 2B to find forms and plane edges. I add pointy teeth and a scaly surface texture to the top of the plant; for the middle of the plant, I'm thinking about a pitcher plant with teeth lining the inside and ridges to indicate a throat. As I develop the leaves and plant matter, I try to keep to the form edges and the lines indicating plane breaks.

DID YOU KNOW?

The smell of rotting meat that some plants emit is analogous to the sweet smell of other plants; it attracts flies and beetles that assist in the pollination process.

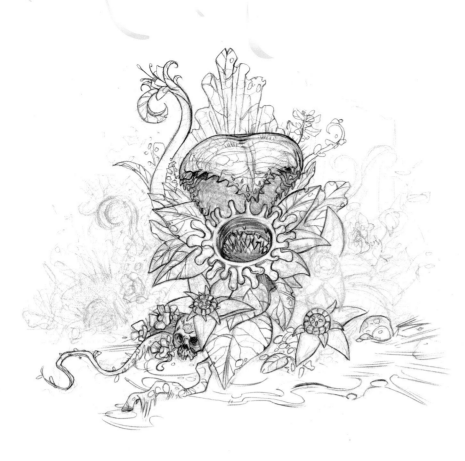

Step Six When working with masses of textures made from many smaller forms, it is helpful to think of it like finding shapes in clouds. Each final line is a decision between the many shapes created during the first steps. So I choose forms that work and erase areas to accentuate my decisions. As I make these forms, I try to add details like small leaves and veins.

Step Seven I continue moving outward to develop the rest of the plant. Placing texture on the plants is like adding wrinkles to cloth. The texture should follow the form underneath: In this case, most of the forms are either dome (leaves) or cylinder (vine/stem) forms. Next I erase areas that face the light source and clean up edges.

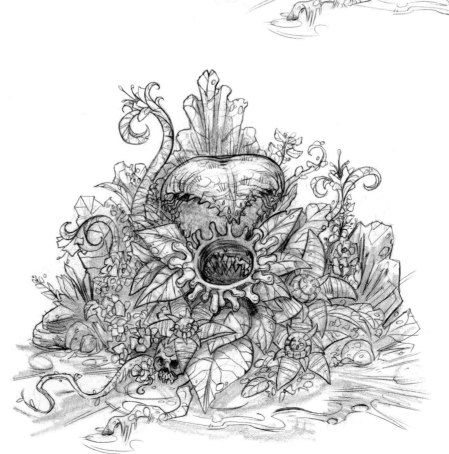

Step Eight I use the side of the 2H to place shadows and to make areas either recede or advance. I also place cast shadows from one level of leaves to the next to help give them form and placement in space.

CTHULHU

From the mind of H.P. Lovecraft came not only a singular creature that terrorized humanity but an entire pantheon of gods, creatures, and worshipers that have been embedded into popular culture. The stories of the Cthulhu (pronounced ka-thoo-loo) mythos have been a huge influence on the horror genre and continue to thrive far beyond the lifetime of Lovecraft himself. Accounts contend that the monstrous being lays in torpor deep in the Pacific Ocean in an antediluvian city that can drive one insane just by trying to comprehend its angles. Cthulhu's followers wait for him and the other Great Old Ones to return and set forth an age of madness, resulting in the end of man. In this project, the challenge is to create a creature that is described as almost unknowable.

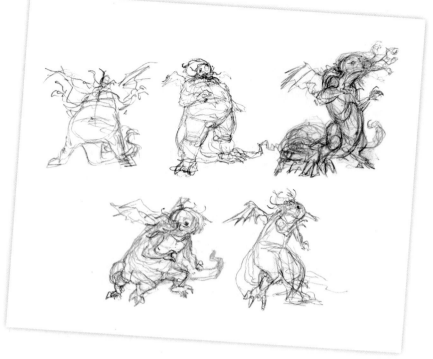

Concept Sketches Descriptions of Cthulhu are primarily in the form of statues. One account tells us that seeing the beast gave one the impression of an "octopus, a dragon, and a human caricature" with "a pulpy, tentacled head surmount(ing) a grotesque and scaly body with rudimentary wings." We also know it is a large creature from a description that it looked as if "a mountain walked or stumbled."

Step One The thumbnail sketches gave me a few ideas, but I wasn't getting the scale I wanted. I use a 2H pencil to lightly draw the basic pose, imagining a horizon line well below its knees.

Step Two Still using the 2H, I use the basic shapes and forms as a guide to place some details that will let me know if I am headed in the right direction. I also start placing lines to indicate perspective and shape, such as the ellipse at the top of the neck and the blocky shapes of the legs. Notice that the viewer's eye level is below the knees.

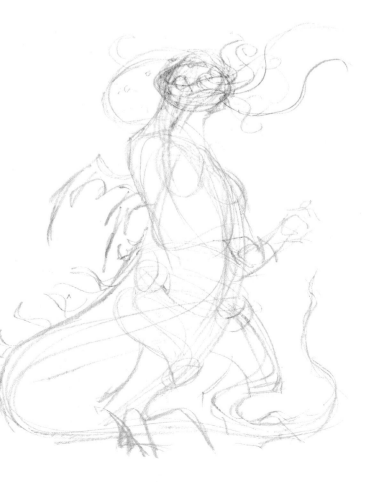

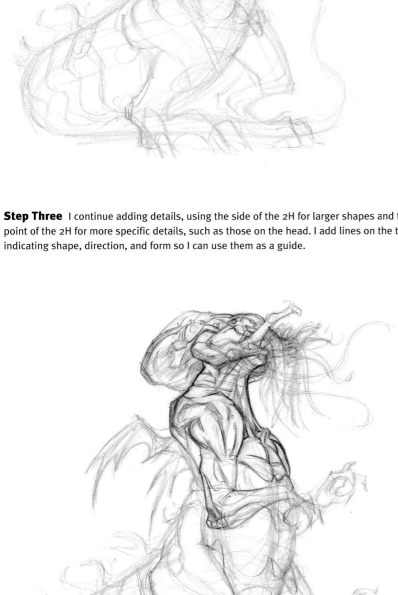

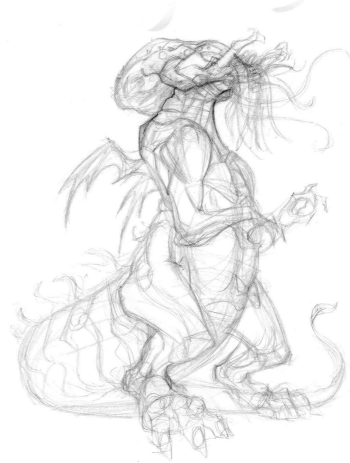

Step Three I continue adding details, using the side of the 2H for larger shapes and the point of the 2H for more specific details, such as those on the head. I add lines on the tail indicating shape, direction, and form so I can use them as a guide.

Step Four I add details and erase areas until I have a good feeling for the character. I also add more specific musculature and surface details. Notice the wrinkles around the neck and how they reinforce the low perspective.

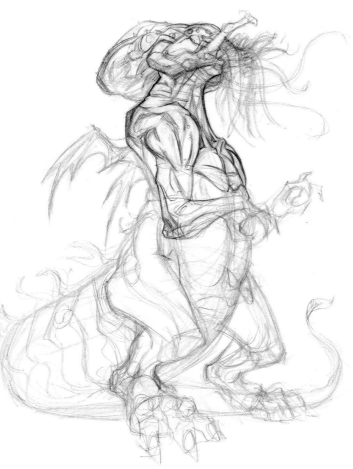

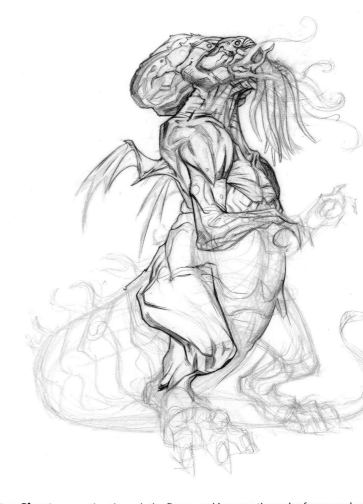

Step Five I switch to a 2B pencil and start to lay in final lines on the upper half of the body. I want to make sure the perspective is reading correctly and that it looks like the viewer is looking up at the gigantic creature. At this point, I'm mostly just outlining forms and finding edges.

Step Six I keep moving through the figure, making sure the major forms read well. I don't like the mandible-esque thing near the mouth so I erase it and change it to another tentacle. I start to place some shadows on the head, chest, and shoulders. All the texture lines of the wrinkles follow the forms underneath them, but they are basically ellipses in perspective, since we are looking at them from below.

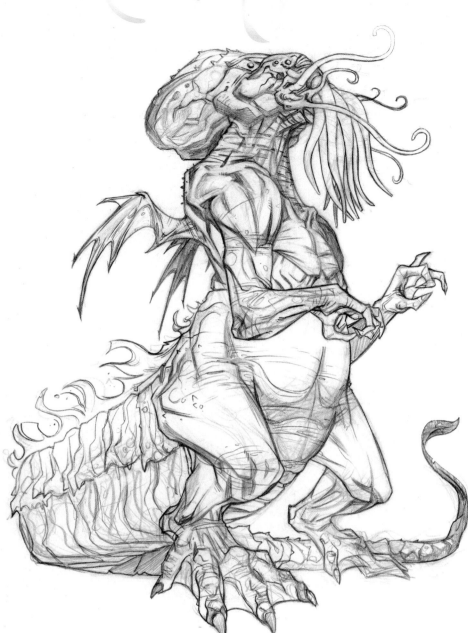

Step Seven Still using the 2B, I finish the rest of the final lines, indicating texture and placing deep shadows where appropriate. Because the scale is so large, I silhouette forms that recede, such as the back wing, shoulder, and tip of the tail.

Step Eight Using the side of the 2H, I go back through and add large areas of shadow to help define form, focusing on the large masses first and then smaller areas. I also use the 2B to add wrinkles, pointy areas, and bits of scale that are shedding off like dry skin.

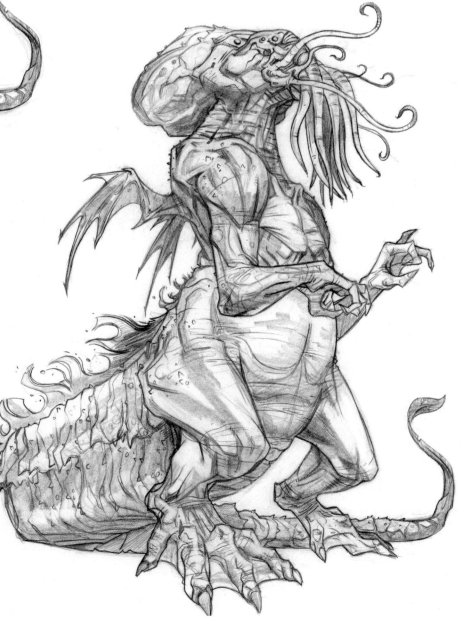

▶ **Step Nine** After I scan the drawing, I tweak it a bit in order to increase the scale of the beast. I decide on a nighttime palette (blues and greens), using undersea colors like aquamarine blue. I shift to warmer colors in the feet and areas closest to the viewer to emphasize atmospheric perspective.

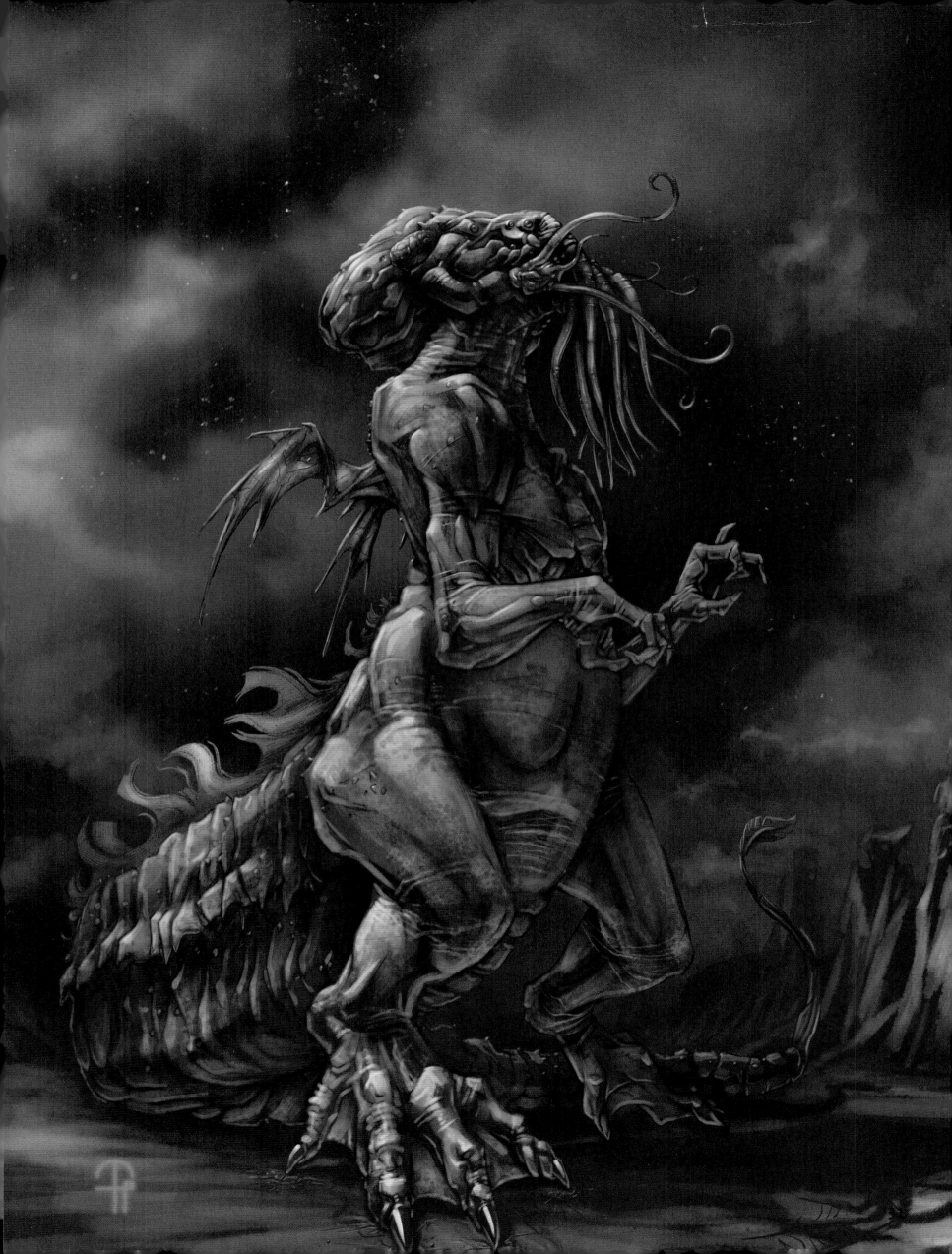

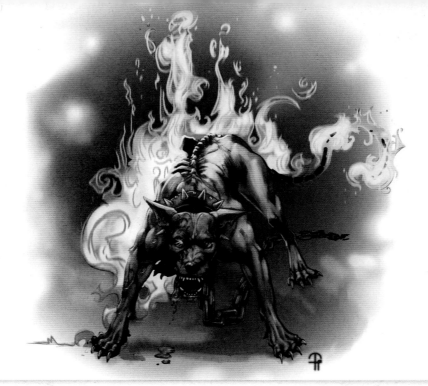

About the Artist

Jacob Glaser is a professional illustrator and student of art who lives and works in Hollywood, CA. A childhood spent watching his grandmother draw monsters for him encouraged a switch late in college from Electrical Engineering to Illustration. After receiving his BFA, he worked at several companies as a staff artist and art director before becoming a full-time freelance illustrator. Professional credits include work on live action and animated films, as well as comic books, role-playing games, and video games. A fan of stand-up comedy, sci-fi/fantasy audio books, and indie music, he can often be found listening to one of these while drawing and painting in his home studio. Visit www.jacobglaser.com for more information.